mixing
watercolors

Author: Parramón's Editorial Team
Illustrator: Parramón's Editorial Team

All inquiries should be addressed to:
Barron's Educational Series, Inc.
250 Wireless Boulevard
Hauppauge, New York 11788
http://www.barronseduc.com

Library of Congress Catalog Card No. 97-42795

International Standard Book No. 0-7641-0551-5

Library of Congress Cataloging-in-Publication Data
Para empezar a pintar mezcla de colores acuarela. English.
 Learning to paint, mixing watercolors / [author, Parramón's
Editorial Team ; illustrator, Parramón's Editorial Team].
 p. cm.—(Barron's art guides)
 ISBN 0-7641-0551-5
 1. Watercolor painting—Technique. 2. Colors—Mixing.
I. Parramón Ediciones. Editorial Team. II. Title. III. Series.
ND2420.P36413 1998
751.42'2—dc21 97-42795
 CIP

Printed in Spain
9 8 7 6 5 4 3 2 1

BARRON'S ART GUIDES

LEARNING TO
PAINT

mixing watercolors

BARRON'S

Contents

COLOR GROUPS

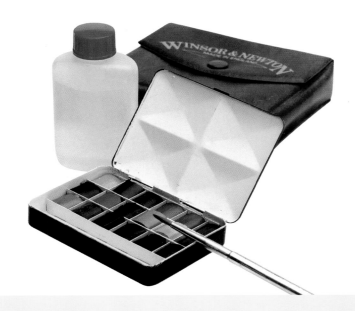

The simple composition of watercolor paints, gum arabic, and pigment, and the purity of their colors, make them ideal for mixing. And although professional painters can mix their colors almost by intuition, the process may seem to be a mystery to the novice.

This book has been created to reveal to the beginner the secrets of the fascinating world of mixing watercolors. Readers are guided, step by step, through the basics of color theory that will enable them to make the most complex tone or hue. The exercises included provide all the knowledge necessary to paint any subject, using only seven colors, selected to allow readers to make their own mixes and gain confidence in the technique. Only practice will give the beginner fluency in the world of color; what might seem at first to be a mistake may prove later on to be an important discovery that the artist can use to solve other problems.

How to Mix Paint

The transparency and brightness of watercolors give them a special charm. These qualities are achieved because this type of paint is dissolved in water and applied over the paper in a thin film.

1. Prepare the first color in the paint well by adding a little paint and a few drops of water. The amount of water depends on the intensity of the tone you want.

In the Paint Well

When an artist has to cover a large area of paper with a single color, the mixes are often carried out in a paint well or saucer. This allows a large enough quantity to be made to ensure that you won't be left short. A greater or lesser proportion of water is added to the mix depending on the intensity of the tone desired.

2. Then, spread it onto the palette by pressing down lightly. This forces the hairs to release water and dilute the paint.

On the Palette

The most common way to mix watercolors while painting is to do it on the palette, so it is important to learn and practice the correct method for doing this until it is mastered. To make sure that your colors are clean, you should rinse your brush in water before starting a new mix.

1. To mix colors on the palette, first load a little paint onto a clean, wet brush.

3. Next, take a little of the second color you are going to use in the mix.

4. Mix the two colors on the palette by adding a lesser or greater amount of each depending on the type of tone or hue you want.

2. Then, add another color without diluting it, taking advantage of the liquid state of the first tone. Notice how the third color appears almost immediately.

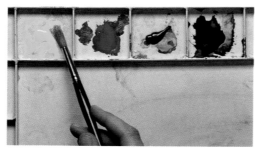

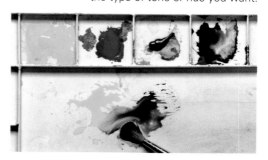

On the Paper

If you are painting quickly and are already aware of how colors respond in mixes, you can make some of them directly on the paper, skipping the palette. This method will save time and also give spontaneity to your work. But, if you are not absolutely sure of a mix, it is best to make a few tests first on a separate piece of paper.

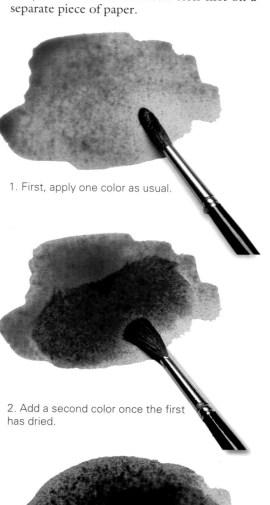

1. First, apply one color as usual.

2. Add a second color once the first has dried.

3. Use a brush to mix the two colors together. Here, the paper has been used as if it were a palette.

With Glazes

Intensifying tones and mixing colors by superimposing glazes—fine films of transparent color—is a common practice in watercolor painting. The results are almost the same as those achieved by mixing the paint in other ways, although it is much more difficult to get a uniform hue with this method.

In order to mix colors by superimposing glazes, first apply a color and then let it dry. Afterward, paint a glaze of another color on top. This produces a third color, the result of the two mixed together. In this case, crimson and yellow produce orange.

Cerulean blue was superimposed over yellow to get this green.

Cerulean blue over crimson gives you purple.

REMEMBER . . .

■ It is difficult to measure the proportions of paint and water exactly; so, when you need to cover a large area of the paper with one color, make sure you mix enough. If you run out, you will find it nearly impossible to mix the exact same color again.

The Three Primary Colors

There are three primary colors: yellow, red, and blue. Their equivalents in watercolor paints are medium cadmium yellow, alizarin crimson, and cerulean blue. By mixing these three colors together in different proportions, the artist can make all the tones and hues that the human eye is capable of seeing.

Yellow

The color that comes closest to primary yellow in watercolor is medium cadmium yellow. Yellow is the lightest of the three primary colors, and brightens others when mixed. On the other hand, the other colors darken yellow.

Medium yellow is the warmest and brightest of the three primary colors. When mixed, it brightens the other colors.

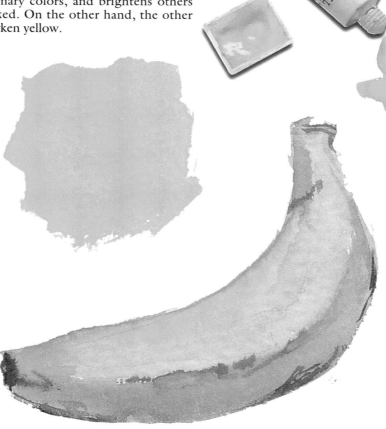

In the chapter Yellow (pages 42–43), you will find more information on this color, and a step-by-step exercise in which you will explore yellow and its various tones.

Red

Alizarin crimson is the paint that most represents the primary color red.

■ It is essential for painters to know everything about the three primary colors, because all other colors come from them.

■ By mixing two primary colors together, you get secondary colors; if you mix three primary colors together, you get neutral gray colors.

REMEMBER . . .

Although red can be included within the range of warm colors, it is actually between yellow and blue.

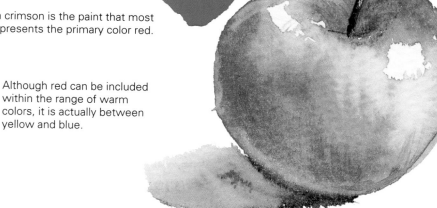

For more information on the tones that this color can produce, see Reds and Oranges (pages 44–45), where you will find a step-by-step exercise to paint a picture using these colors, as well as a more in-depth explanation of their characteristics.

Blue

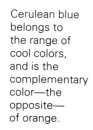

Cerulean blue is the paint that best represents the primary color blue.

Cerulean blue belongs to the range of cool colors, and is the complementary color—the opposite— of orange.

There is also a chapter dedicated exclusively to blue (pages 50–51) and its corresponding tones and hues.

Basic Techniques

9

Mixing Watercolors

The Three Secondary Colors

Secondary colors are those made by mixing any two primary colors together. Secondary colors are orange, green, and purple, also called violet.

Orange

The secondary color orange is the result of mixing two primary colors: red and yellow.

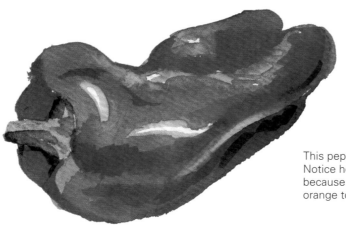

This pepper was painted with shades of orange. Notice how the subject does not have a uniform color, because it was necessary to use various values of orange to suggest the volume of the vegetable.

Important Advice for Mixing Colors

It is important to remember that the intensity of tone in watercolors depends on the amount of water with which you dilute or apply them.

There is a wide range of intermediate shades, or hues, between the darkest and lightest shades of a color. It is important not to forget to clean the brush thoroughly before beginning a mix; any residues of an earlier color will produce unwanted results.

To control the proportions of your mix, it is best to start with the lightest color and then add the darker one to it.

Green

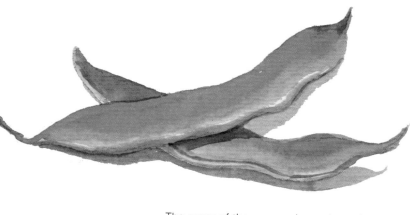

The secondary color green is made from yellow (primary color) and blue (primary color).

The green of these green beans is made by combining cerulean blue and medium yellow. The difference in tones that conveys shapes and shadows is due to the varying amount of water used in applying the paint.

Purple

The secondary color purple is made by combining blue (primary color) and red (primary color).

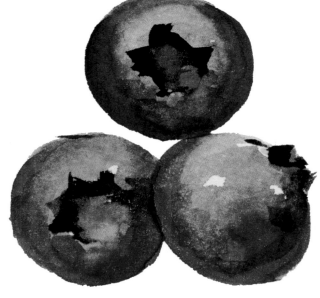

The color of blueberries is very close to the secondary color purple.

The different tones of a color can be made by applying layers of glazes.

In order to create a tonal range from a single color, you only have to dilute the paint in different proportions.

REMEMBER . . .

■ In theory, secondary colors are the results of mixing two primary colors together in equal parts. In practice, you may have to adjust these proportions a little, because the actual pigments representing the primary colors in watercolor may vary slightly or contain impurities.

The Six Intermediate Colors

There are six intermediate, or tertiary, colors: yellow-orange, red-orange, yellow-green, blue-green, blue-violet, and red-violet. An intermediate color is the result of mixing a primary color with its nearest secondary color.

Yellow-Orange

Yellow-orange is the intermediate color made by combining medium yellow (primary color) with orange (secondary color).

Red-Orange

This red-orange is the result of mixing red (primary color) and orange (secondary color).

Yellow-Green

By mixing medium yellow (primary color) with green (secondary color), you get light green.

Emerald Green

The result of combining green (secondary color) with cerulean blue (primary color) is emerald green.

Blue-Violet, or Ultramarine Blue

Mixing purple (secondary color) and cerulean blue (primary color) gives you ultramarine blue.

Red-Violet

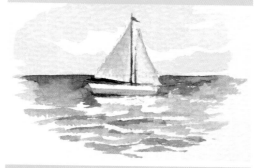

This red-violet is the result of mixing crimson red (primary color) with purple (secondary color).

Complementary Colors

Complementary colors are those that, when mixed together, would make gray or a neutral color because they involve a mixture of the three primaries; for instance, orange, which is the complementary of blue, contains red and yellow. When placed side by side, they intensify the effects of each other and clash. All colors have their complement. You should learn them so you can take advantage of their intensities.

Blue (primary color) is the complementary color of orange.

Red (primary color) is the complementary color of green (secondary color).

Yellow (primary color) is the complementary color of purple (secondary color).

Mixing crimson red (primary color) with its complementary color green (secondary color) produces neutral brown tones.

Mixing cerulean blue (primary color) with its complementary color orange (secondary color) produces a neutral gray.

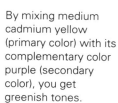

By mixing medium cadmium yellow (primary color) with its complementary color purple (secondary color), you get greenish tones.

Suggested Palette

It is not necessary to have a wide range of colors for painting in watercolor. A range of seven well-chosen colors is enough to produce any hue.

Medium Cadmium Yellow

This color of paint is the equivalent of primary yellow in watercolor. It is the warmest color in this palette and the one that lightens the other mixtures. Because yellow is the color of sunlight, it is found in almost any subject.

Alizarin Crimson*

This color corresponds to the primary color red in watercolor. It is the second warmest color after yellow. These two colors can be combined to produce a variety of reds and oranges. When mixed with blue, it produces purple; when mixed with green, it produces browns.

Burnt Sienna

This color belongs to the group of earth or brown colors, and is often used for tinting and neutralizing other colors. It is essential for making earth and flesh tones. Because burnt sienna is made up of the three primary colors, it is classified as a neutral color.

REMEMBER . . .

■ It is recommended that you test each color on a separate piece of watercolor paper, gradually going from lightest to darkest tones in order to become acquainted with their ranges. The tonal differences of a color are so great that, unless you are an experienced painter, you may get confused when you begin to paint. A preliminary study of your colors will clear up any doubts.

*Don't confuse crimson with magenta, even though the latter can also be used as a substitute for red. Alizarin crimson has been chosen because it produces a purer red.

Why Seven Colors?

All the exercises demonstrated in this book could have been painted using only the three primary colors. Although this would have provided the beginner with an opportunity to understand them, it would have been tedious and unnecessary. The wide range of colors available means that you can skip the most basic mixes and save time. On the other hand, a palette containing too many colors can create confusion. This variety may enable the artist to avoid color mixes altogether, but the resulting paintings will lose their richness of tone, and the painter will never know the fascinating world of color.

For this reason, we have chosen a limited palette made up of seven basic colors that will allow you to easily make any type of mix, and at the same time investigate and experiment with them.

Once you have mastered the techniques of color, you will probably want to increase this palette to between ten and fourteen colors that will enable you to save time and get even more sophisticated tones. For the time being, it is recommended that you use the colors suggested here, and follow the step-by-step exercises in the following chapters to practice developing specific colors. If you do this, you will be amazed by the way colors behave, and by the end of this book you will have acquired a firm footing in color mixing that will improve your paintings and make your hobby far more enjoyable.

Cerulean Blue
This color corresponds to the primary color blue. It is a cool color that is often used for mixing other tones of blue, as well as cool greens and grays. Cerulean blue is frequently used to paint skies, and is combined with other colors to render water.

Ultramarine Blue
This color provides a base for mixing other blues, such as Prussian blue or cobalt blue. Ultramarine blue is also the base for other blue colors relating to water, and for painting the uppermost limits of the sky. Like cerulean blue, this color is also used in mixes to make grays and reinforce shadows.

Emerald Green
This color is a basic cool green, because it is composed of three parts cerulean blue and one part yellow. Emerald green can be used as a base for practically any other shade of green, and to increase the range of blues.

Ivory Black
This is a pure black that is used for tinting, neutralizing, and, in certain cases, reinforcing colors.

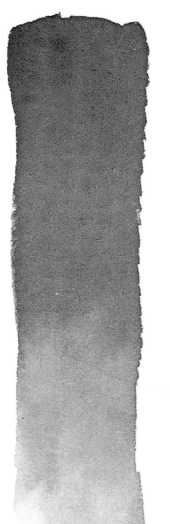

Mixing One Color with the Others

One good way to become acquainted with the seven colors of your palette is to mix each one with all the others: You will be amazed at the results

Mixing Crimson with the Other Colors

The first exercise involves mixing a warm color, crimson, with each of the other colors of the palette. Crimson is one of the most important colors, because its versatility in mixes makes it one of the most commonly used.

Crimson has been chosen to mix with the other colors.

By adding an equal amount of yellow, you get the secondary color orange. If you had added a little less yellow, you would have made a shade of red. See page 10.

By mixing it with burnt sienna, you make a reddish brown.

Mixing crimson with cerulean blue produces this type of mauve. If the artist had mixed it half and half, the result would have been the secondary color purple; see page 11. This same mix can be found on the following page. Notice the difference in color when the proportions are altered.

Crimson mixed with ultramarine produces this intense violet.

Emerald green mixed with crimson produces this neutral, brownish gray color with a hint of violet.

These are the six remaining colors that will be mixed with crimson.

Blacks neutralize and darken colors, producing grays.

Mixing Cerulean Blue with the Other Colors

It is also interesting to practice with the color opposite crimson in terms of "temperature" and effects: cerulean blue, another primary color. Notice the difference in colors that are produced in the following mixes.

Cerulean blue mixed with yellow produces the secondary color green; see page 11. Remember, if the artist had added more yellow to the mixture, the green would be brighter; if the predominating color were cerulean blue, the result would be a darker blue.

Combined with crimson, cerulean blue gives you this purple, another secondary color; see page 11.

When cerulean blue is added, burnt sienna suddenly becomes olive green.

Mixing ultramarine blue and cerulean blue produces an almost perfect cobalt blue.

Cerulean blue, another primary color, is the color chosen for this exercise.

Mixing it with emerald green gives you turquoise.

Black darkens cerulean blue and produces this color, very close to Prussian blue.

The artist will mix cerulean blue with the other colors of the palette.

REMEMBER . . .

■ These mixes have been done randomly, paying little attention to proportion.

■ Don't forget that a mix of two colors can produce several different colors according to the proportions of paint, and how much water is used to thin it. Notice, for example, the differences in the colors on both pages where crimson and cerulean blue were mixed.

Range of Cool Colors

The so-called "cool" colors produce a sense of airiness and distance, and seem to recede from the observer. In nature, they are the colors of the horizon and distance.

About Cool Colors

In landscapes, cool colors are usually found on, or near the horizon. The entire range of blues is cool, although certain other colors, such as greens and violets, are also essentially cool because they contain a lot of blue. Cool colors seem to retreat from the observer, and generally give a sense of openness and weightlessness.

The cool color range is as wide as that of warm colors, although it produces fewer hues. To produce warm colors, the artist can experiment with two colors: crimson and yellow; for cool colors, only blue should be used as a base. At least half the mixture should consist of blue to achieve the coolest blues and violets. Adding green, which is partly yellow, increases warmth.

This sea blue contains a mixture of 95% cerulean blue and 5% emerald green.

This cobalt blue was made by mixing equal parts of cerulean blue and ultramarine blue.

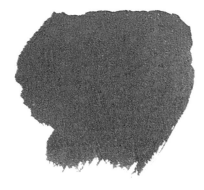

This deeper hue is a combination of 70% ultramarine blue and 30% emerald green.

This purple combines 90% ultramarine blue and 10% crimson.

This horizon blue is 85% cerulean blue and 15% burnt sienna.

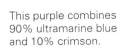

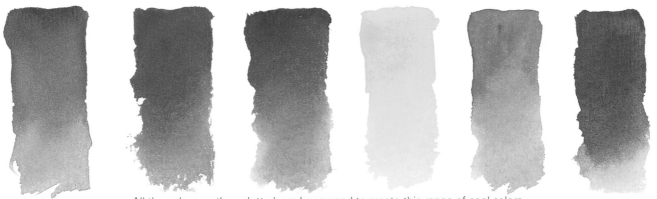

All the colors on the palette have been used to create this range of cool colors.

This emerald green hue is 90% emerald green and 10% ultramarine blue.

This green has almost the same proportions as the previous one, except that 10% yellow has been mixed with the 90% emerald green.

Another purple hue was made by combining 75% ultramarine blue, 15% crimson, and 10% black.

This vivid green was made by mixing 60% emerald green, 35% yellow, and 5% burnt sienna.

Equal parts of ultramarine blue and crimson produce this violet.

Emerald Green

If you observe closely how the colors in this range are composed, you will see that several of them use emerald green as their base color. You will probably wonder why this color has been used when cool colors are supposed to be based on blues.

The answer is very simple, and, if you have followed this book chapter by chapter, you will probably already know why: Emerald green is made up of cerulean blue and secondary green.

Secondary green, in turn, is composed of yellow and cerulean blue; so, emerald green is three-quarters blue and one-quarter yellow, and is therefore a cool color. (See pages 12–13.)

REMEMBER . . .

■ The predominant color in cool colors is blue.

■ Some greens and violets that are composed of half warm and half cool colors become neutral, so their characters will depend on the colors that surround them.

Range of Warm Colors

Warm colors seem to approach the viewer. They also give a sense of heaviness and warmth. In nature, they are the colors you see in the foreground, and those created by the midday sun. In this chapter the artist develops a range of warm colors by mixing the seven colors on the palette.

About Warm Colors

The first image that "warm" colors conjures up is a range of yellows, oranges, and reds. This first impression is correct, as these are the main warm colors. There are, however, many other colors that are warm, but are not quite so obvious. This is the case of ochers, earth colors, and some greens; as these colors are often composed of all three primary colors, they fall into the category of neutral colors.

Despite this, they have been included in the range of warm colors developed based on the artist's palette, and not only on the three primary colors.

This yellow contains 95% yellow and 5% crimson.

This ocher was made by combining three parts yellow and one part burnt sienna.

This orange combines 30% crimson and 70% yellow.

Crimson and yellow were mixed evenly to produce this dark orange.

This light garnet is 95% crimson and 5% ultramarine blue.

Every color on the palette except black has been used to make this range of warm colors.

This dark ocher is a result of mixing equal amounts of yellow and burnt sienna.

This green has almost the same proportions as the ocher, but with the addition of 5% emerald green.

A brown resulting from 95% burnt sienna and 5% cerulean blue.

A more complicated combination has been used to make this olive green: 40% yellow, 30% crimson, and 30% emerald green.

A light green made by combining 90% yellow, 8% cerulean blue, and 2% burnt sienna.

Proportions

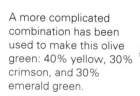

In these three chapters, the different proportions of paint in the various color mixes have been expressed primarily as percentages. In the practical, step-by-step exercises that follow, this form of expressing proportions will no longer be used because it is simply not possible to measure the proportions of watercolors exactly, and because artists don't use those terms. It seems better to use artists' language which, although not as precise, does leave room for experimentation, and developing an intuitive sense of color mixes. As you do these exercises and become familiar with the color mixes, you will be surprised at how accurately you can deduce the composition of a color just by looking at it.

REMEMBER . . .

■ Warm colors are those with a predominant proportion of red or yellow.

■ Warm colors appear to "approach" the observer, so they are generally used for painting the objects in the foreground of a picture.

Range of Neutral Colors

Neutral colors are also sometimes called grays. They are neutral because they always contain a portion of all three primary colors, and are difficult to define.

About Neutral Colors

A watercolor artist seldom applies the paint to the paper straight from the tube or the tablet. He usually mixes colors and changes their hues by adding a touch of another color in an attempt to reproduce the infinite range of colors in nature that result from different effects of the light. So the artist not only alters existing colors, but also creates new ones in an attempt to reproduce those present in nature.

This makes using neutral colors inevitable. The colors in this range are neither warm nor cool, but may take on characteristics of either depending on how they are mixed and what they are next to.

This green is an equal mix of emerald green and burnt sienna.

A bluish gray is made by combining 70% black and 30% ultramarine blue.

This mauve contains 40% crimson, 30% emerald green, and 30% black.

This brown was created by combining 75% burnt sienna and 25% black.

This gray, with its bluish tinge, is a combination of 75% cerulean blue and 25% black.

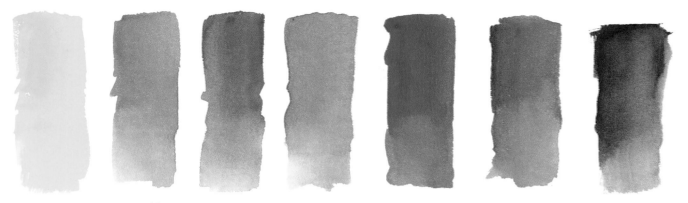

All the colors of the palette were used to paint this range of neutral colors.

This gray combines 40% cerulean blue, 10% burnt sienna, and 50% black.

This color is a dilute mix of 75% black and 25% yellow.

This earth color contains 30% crimson, 60% yellow, and 10% black.

This is a highly diluted, neutral gray; a mix of 90% black and 10% ultramarine blue.

This warm gray is 60% yellow, 30% crimson, and 10% cerulean blue.

Black

You may have noticed that most of the colors in the neutral range contain some black. Remember, as was stated earlier, that neutral colors contain part of each of the three primary colors, and black is made of these three colors mixed in equal parts.

REMEMBER . . .

■ Neutral colors are also called grays, or, to put it another way, grays are almost always neutral colors.

*T*ones

This chapter describes an exercise in which a single diluted color, or wash, is used. This is the best way to understand how to dilute paints to get a scale of tones from a single color or hue, and how to balance these tones correctly.

A White Kitchen

The color chosen for this exercise contrasts most with the white of the paper: ivory black.

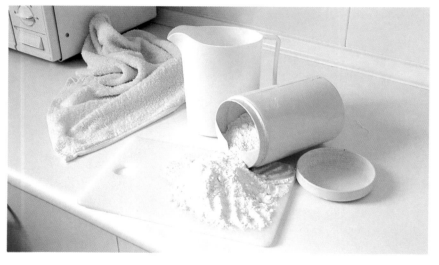

Any subject is suitable for watercolor. The medium is especially good for quick studies in wash or for making notes. In this case, the artist paints a corner of a kitchen in which everything is white. Shadows will be used to define the volumes of the objects.

1

1. After the preliminary drawing, the artist dilutes the color on the palette, and, using a medium tone, starts to define the forms by means of their shadows. If you are not skilled at working with tones, it is important not to use too dark a tone during the early stages of the painting.

2. As the exercise continues, slightly darken the parts that seem to need it, trying not to deepen the tone of the shadows too much. It is better to leave this for a later stage.

2

3. The artist has painted the wall in the background, and slightly altered the white of the table's surface. After examining the overall tones, you can deepen the shadows that the can of flour casts on the table.

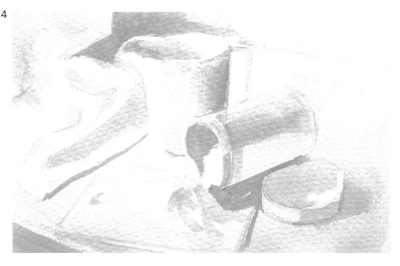

4. After darkening the shadows of the can, and the corner in the background, pause again to observe the overall effect.

5. There are still some shadows that need a darker tone. A glaze made from the previous color is applied to the cloth and the can of flour to provide it.

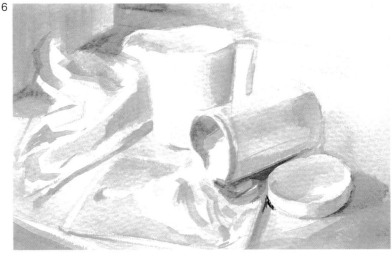

6. Continue by darkening parts of the corner in the background, and the side of the oven, then the can of flour and the surface of the table in the foreground. Now consider the work finished.

This example shows several of the tones used in the above exercise. You can see how the strip painted across the other five darkens the underlying colors. Notice also how this exercise has followed the basic technique of watercolor painting; that is, the artist worked from light to dark, applied glazes, and layered them until getting the correct balance of tones.

REMEMBER . . .

■ In watercolor, the artist paints from light to dark. You always paint the light tones first, because you cannot lighten a dark tone that has already been painted. Painting too dark a tone in the early stages forces the artist to darken the rest to keep tonal balance. This generally produces an overall result that is too dark.

Mixing Yellow and Black

Yellow is generally the brightest color, whereas black is the darkest color, representing the complete absence of light. Painting with a combination of these two colors is an interesting exercise because of their contrast and the wide variety of hues you can make by combining them.

For this exercise, the artist has used the ivory black and medium cadmium yellow on the palette.

These are some of the main hues, all created by mixing yellow and black, used in this exercise. Tone (a) is a half-and-half mix; (b) contains more yellow than black; (c) is highly diluted yellow; whereas (d) is black, which is also very diluted.

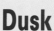

Dusk

The artist will paint this scene of a boat returning to port at dusk. As you can see, this is a dark image that requires the use of black, whereas the sky is lit up in yellow. The remaining colors are suggested by using mixes of these two.

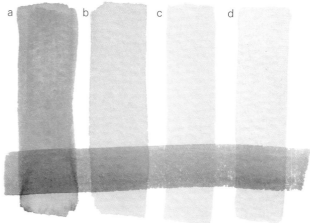

a b c d

1. First, the artist applies a pure, highly diluted yellow for the sky, and a denser yellow for parts of the water.

1

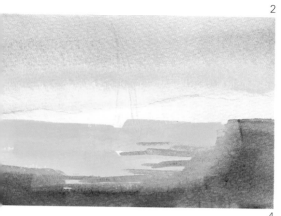

2

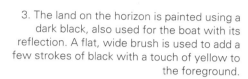

2. The artist waits for the first yellow glazes to dry, then applies highly diluted black to the sky, and a deeper black to part of the water. Notice how even these first brushstrokes can begin to suggest the reflections in the water.

3

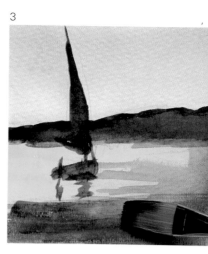

3. The land on the horizon is painted using a dark black, also used for the boat with its reflection. A flat, wide brush is used to add a few strokes of black with a touch of yellow to the foreground.

4

4. Black, again tinged with a little yellow, and a fine brush are used to represent the small reflections on the water's surface. In some, the paint is diluted to lighten the tone, whereas in other areas an undiluted color is used.

5

On the palette, you can see the two colors in their pure state, and the different hues they produce when mixed.

5. Pause now to stand back and consider the painting as a whole. The artist has just darkened the left-hand side, and can now see that the tones of the land, water, and sky are not properly balanced.

6

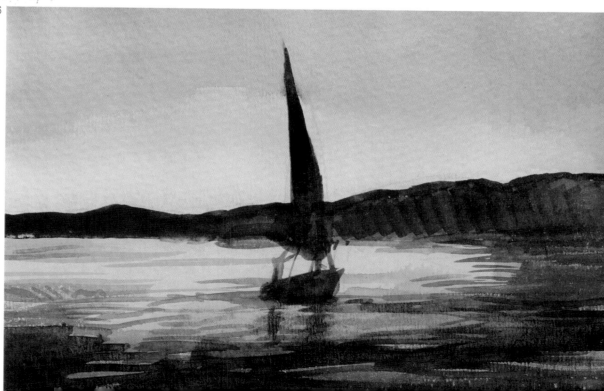

6. To finish off the painting, the artist darkens the areas that were too light using soft strokes that let the underlying color show through occasionally. They also suggest the volume of the water. The land has been painted using steady, horizontal brushstrokes.

Orange and Blue

Orange is an entirely warm color, because it is made up of yellow and crimson, whereas blue is the epitome of a cool color. Combining the two produces a contrast in "temperature," and a rich spectrum of grays.

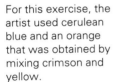

For this exercise, the artist used cerulean blue and an orange that was obtained by mixing crimson and yellow.

a b c d e f g h

In these strips, you can see some of the different hues and colors produced by combining cerulean blue and orange: (a) contains more cerulean blue than orange; (b) in this case, there is more orange, and the resulting color is highly diluted; (c) cerulean blue diluted and "muddied" by adding a little water already used for painting; (d) diluted orange; (e) orange, diluted with a touch of cerulean blue; (f) orange, with a touch of undiluted cerulean blue; (g) pure orange; (h) a mix of equal parts of both colors, semidiluted. The dark glaze is color (h) but with a little more orange added; the light glaze is diluted orange.

Boats

This group of boats offers an interesting contrast of warm and cool colors: orange and blue.

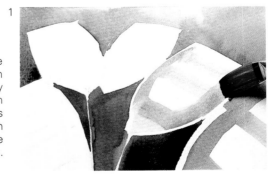

1

1. Parts of the water are rendered using pure cerulean blue, other parts by a nearly equal mix of orange and cerulean blue, though the darker parts have more blue. Pure cerulean blue will be used for painting the inside of the blue boats.

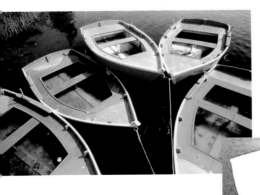

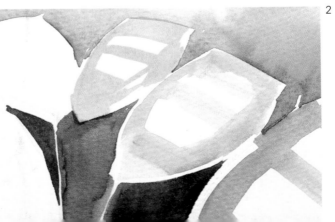

2

2. The artist paints the orange boat, then stops to mix the other colors.

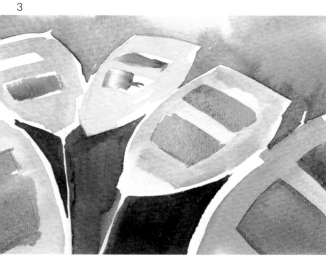

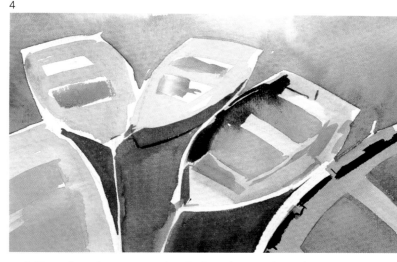

3. One of the green boats is painted using diluted cerulean blue. The other is painted using a mix of both blue and orange, with a larger proportion of orange. The ocher inside of the blue boat on the right is orange with just a touch of cerulean blue.

4. Now, the artist suggests the shadows by superimposing glazes over existing paint that are darker variations of the previously used tones.

5

REMEMBER . . .

■ When colors are mixed on the palette, it becomes dirty, as does the water used for painting. These paint residues can actually be useful. Many artists even choose to "dirty" their pure colors with them when needed.

■ When you are unsure which color has been used to neutralize a pure one, assume that either the dipping water or the paint leftovers on the palette have been used.

29

5. The artist adds the finishing details, still developing new hues with the necessary mixes of orange and blue.

You can see on the palette most of the colors created by mixing orange and cerulean blue. Some have not been touched, whereas others have been completely used up.

6

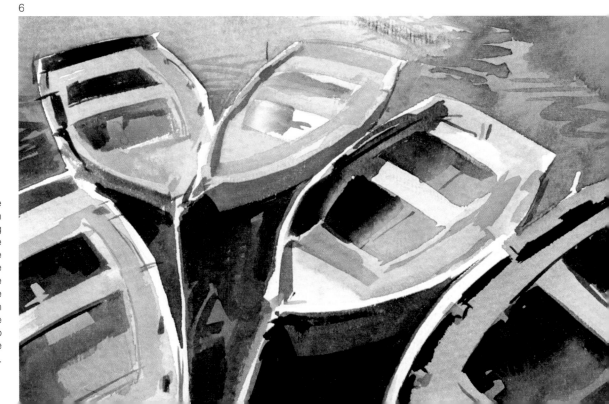

6. The ripples on the water have been painted as a finishing touch, using the same darkish color as the background and gentle brushwork. Notice that a pure orange glaze has been painted over the orange boat to underscore the contrast.

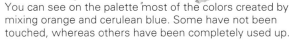

Red and Green

Red and green are the complementary colors that produce the strongest chromatic contrast. Here, the artist paints a color exercise, using green (a cool color) for the shadows, and red for the warm, luminous colors.

Two complementary colors are going to be used: the artist will mix cerulean blue and yellow to make the green, and crimson and yellow for the shade of red.

These strips show the different hues the artist made for this exercise: (a) this mauve is a red, tinted with a little green, and then applied very thinly over the paper; (b) the same as the previous mix, but with a little more green; (c) here, more red has been added; (d) a semidiluted red practically becomes magenta; (e) green. The horizontal strip is a brown resulting from a mix of both complementary colors.

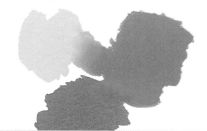

A Nude

A nude has been chosen for this exercise to demonstrate that with just two complementary colors, the artist can paint and represent the colors of flesh.

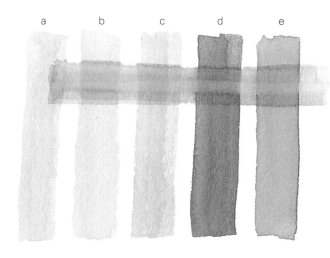

a b c d e

1

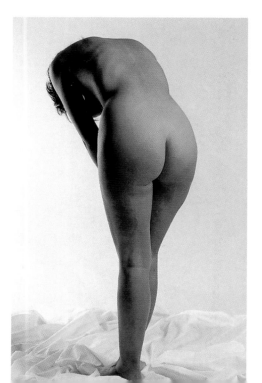

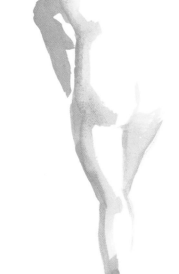

1. The artist begins by blocking in the areas of shadow with different tones of green.

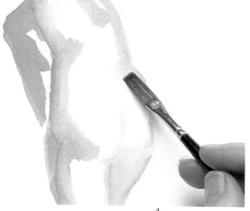

2

2. The artist then applies a little red to give shape to the back.

3. The artist continues to work downward with the red, diluting the color to lighten the tone, and allowing it to mix smoothly with the green in some areas.

3

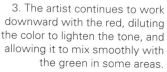

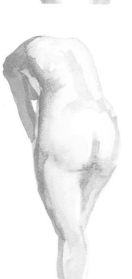

4

4. Using a deeper tone of red, the artist paints the untouched areas on the arm and hip line, and then pauses to see how the tonal balance is developing.

5

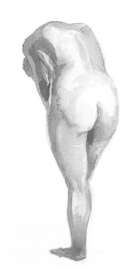

5. The artist darkens the red in the areas that seem to need it, such as the elbow area and below the buttocks.

6. To finish off, the artist mixes together equal parts of both red and green to get a highly diluted brown. This is used to paint the background. To get the color for the floor, the artist first paints the area red, then superimposes green glazes.

6

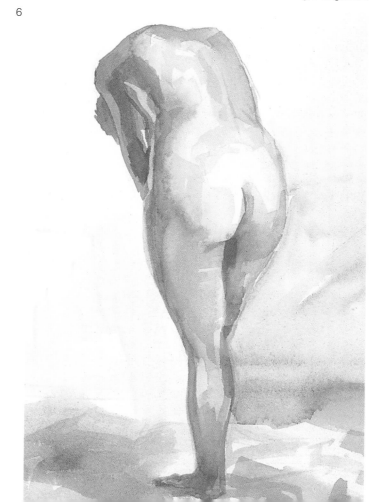

REMEMBER . . .

■ Study the finished exercise closely and you will see that the result is not as strange as you may have expected. Notice the different hues of the body, and how many different kinds of brown have been used to suggest true flesh colors.

You can see some of the tones on the palette that were used for painting this nude.

Painting with the Primary Colors

To prove the statement that any color in nature can be made by using just the three primary colors, the artist here paints an exercise using just these three.

You can produce an infinite range of colors from the three primary colors, but only those used for the exercise appear here: (a) contains yellow and crimson red with a little blue; (b) the same color containing more yellow and rather diluted; (c) brown, containing the three colors, with a larger percentage of crimson red; (d) cerulean blue tinted slightly with some leftover paint from the palette; (e) a mix of cerulean blue and yellow; (f) vermilion of crimson red and yellow, a color midway between red and orange.

In this exercise, the artist uses only the three primary colors: cerulean blue, crimson red, and yellow.

a b c d e f

A Coffee Grinder

This coffee grinder against a black background is the subject for the painting limited to the three primary colors.

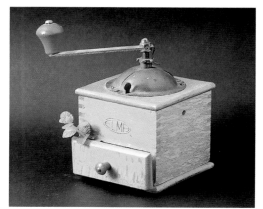

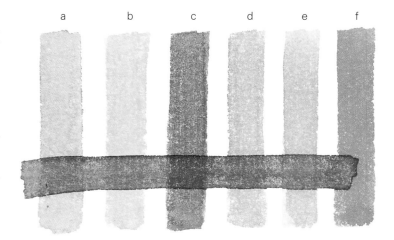

1. The artist has started with the background, because it is the darkest area and determines the overall tones of the work; the artist mixed the three colors in equal proportions to make this transparent black. The diluted ocher color used for the wood is a mix of crimson red and yellow, tinted with a little of the background color.

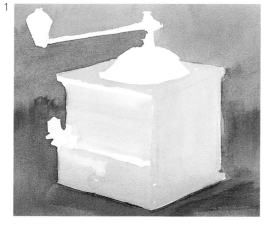

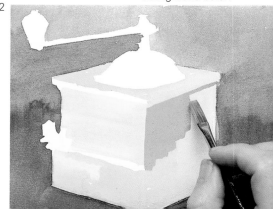

2. The artist has darkened the wood tone by adding a little crimson red, taking care not to dilute it too much.

3

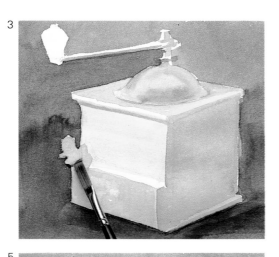

3. The blue area is painted with a slightly muddied cerulean blue. The sprig of mint was painted with a mix of cerulean blue and yellow.

4

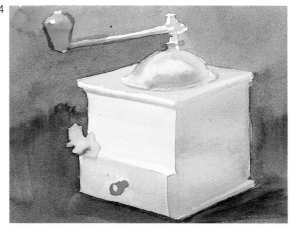

4. The red for the details is made by mixing crimson and a touch of yellow.

5

5. The artist added a little cerulean blue and crimson to the ocher used to paint the base of the grinder, and has developed reddish and violet-tinged browns for painting the shadows and other details.

REMEMBER . . .

■ There is no limit to the number of colors you can make using the three primary colors, although they do not all appear in this chapter. It is recommended that you do several exercises using just the three primary colors to acquire practice in mixing colors; you will be surprised by the number of colors you can make.

■ You will find more information about primary colors on pages 8–9.

6. In this photograph of the completed painting, you can see how several soft glazes have been applied.

33

6

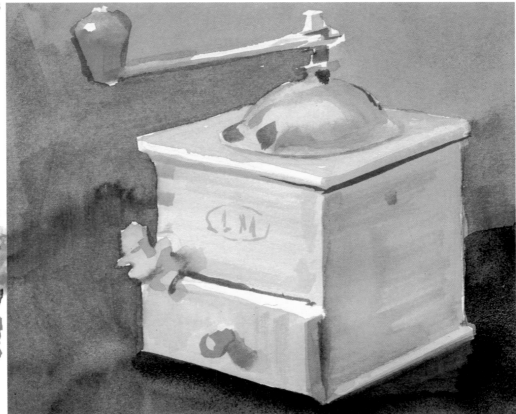

Here, on the palette, you can see how the black that was used for the background takes up most of the space. There are also traces of the other colors the artist mixed.

Painting with Cool Colors

The exercise in this chapter involves using cool colors, or hues, although the artist will use some yellow, a warm color. The artist will use the cool colors on the palette, and mix them to make other hues that are needed.

The artist will paint this exercise using just four of the colors on the palette: yellow, a warm color; emerald green, ultramarine blue, and cerulean blue, all cool colors.

In this range, you can see the colors that have been made: (a) a highly diluted mix of cerulean blue and emerald green with a touch of yellow; (b) a mix of ultramarine blue and emerald green; (c) cerulean blue and emerald green without any yellow; (d) a highly diluted yellow with just a touch of cerulean blue; (e) a pure, semidiluted cerulean blue; the horizontal strip is the same color as (a).

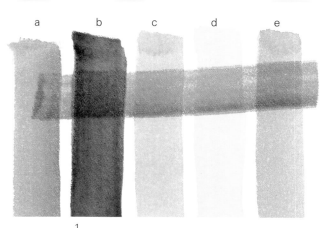

1. The artist begins by applying a pure, semidiluted cerulean blue wash to the sky; to the horizon line, the artist adds some diluted yellow.

Sky and Water

The artist has chosen this particular scene for an exercise as it contains blues that are naturally cool at this time of day.

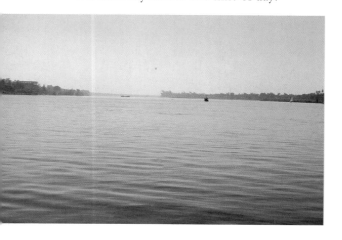

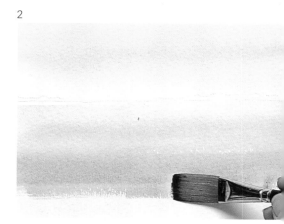

2. For the water, the artist makes up a muddy turquoise with a mix of cerulean blue and diluted emerald green.

3. Once the first wash has dried, the land is rendered using a mix of ultramarine blue and emerald green.

3

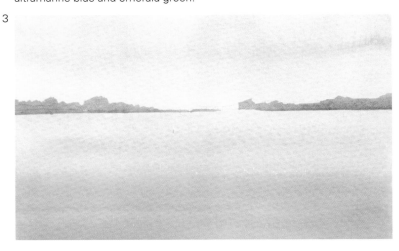

4

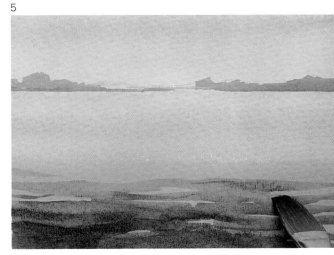

4. The artist applies a deeper tone of the previous mix with a touch more blue to suggest the rippling surface of the water.

5

REMEMBER...

■ You should paint the background quickly so that no "breaks" (abrupt changes of tone) appear, although this is sometimes a desired effect, because it gives the painting a fresh, spontaneous look.

■ You will find more information about cool colors on pages 18–19.

5. Before these last brushstrokes have time to dry completely, the artist softens the lines with a damp, flat brush, so that they merge into each other.

Notice how the three colors look on the palette when the artist has just started to combine them.

6

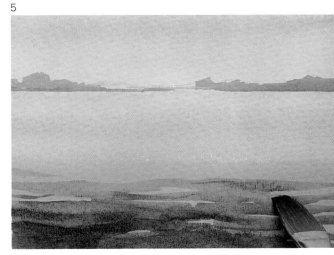

6. As a final touch, the tone has been diluted to lighten it as the artist approaches the horizon. In the foreground, the artist has left the darker, deeper, more contrasting tones.

Painting with Warm Colors

At certain times of the day, a landscape or a seascape may be bathed in an orange light that makes all the colors seem warm.

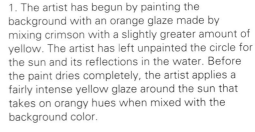

Just three colors are going to be used for this exercise: crimson and medium yellow, both warm colors, and ivory black.

This is the range of tones that have been developed using these three colors: (a) orange containing crimson and a slightly larger proportion of yellow; (b) the same color, but with a little more crimson; (c) red containing no yellow, but a touch of black instead; (d) the same color as (c) but with a larger proportion of black; the vertical strip is a pure yellow.

a

b

c

d

A Sunset

A sunset has been chosen as the subject for this exercise because the entire scene is bathed in an intensely warm light.

1. The artist has begun by painting the background with an orange glaze made by mixing crimson with a slightly greater amount of yellow. The artist has left unpainted the circle for the sun and its reflections in the water. Before the paint dries completely, the artist applies a fairly intense yellow glaze around the sun that takes on orangy hues when mixed with the background color.

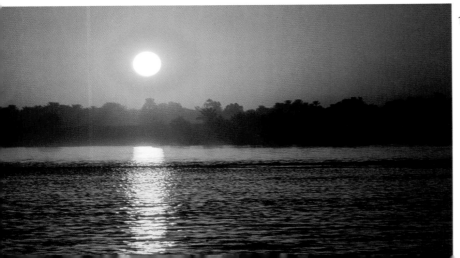

1

2

2. On the left, the artist intensifies the hue of the sky by using a crimson glaze.

3

3. A less diluted version of the previous crimson is applied to the water to produce the same effect as in the sky: the underlying color gives it an orangy cast. The sun's rays are painted in yellow.

4

4. When these preliminary glazes have dried, the artist mixes crimson and black for the group of trees. The same color is used to apply a few brushstrokes to the water, and the nearest trees, adding a touch more black.

REMEMBER . . .

■ Layering glazes can be a substitute for mixing. If you want clearly defined brushstrokes, you must wait until the first layer of paint has dried; otherwise, the pigment will run and the colors will merge together at the edges.

■ You will find more information about warm colors on pages 20–21.

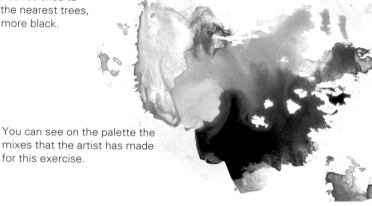

You can see on the palette the mixes that the artist has made for this exercise.

5

5. As you can see in the finished exercise, the surface of the water has been painted with horizontal brushstrokes of varying intensities.

Painting with Neutral Colors

Neutral colors, also considered grays, contain some of each of the three primary colors. This chapter is concerned with demonstrating the differences between these and the other colors. Because neutral colors are present all around us, this exercise is extremely useful for beginners.

The artist will use only five of the seven colors in this exercise: emerald green, ultramarine blue, cerulean blue, burnt sienna, and ivory black.

Here are some of the neutral tones that will be used in this painting: (a) a sepia tone mix of burnt sienna and black; (b) an umber tone darkened with a touch of blue; (c) gray, the direct opposite of color (b), made by tinting cerulean blue with burnt sienna; (d) almost the same mixture as (c), but more diluted, and with a touch more burnt sienna; (e) gray, the same as (c), but more diluted; the vertical glaze is a very diluted burnt sienna, slightly altered by the leftover paint on the brush.

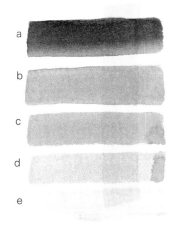

A Stranded Ship

The subject of this painting is a stranded ship made up of neutral colors. On an overcast day like this, the sea and the sky also take on gray, neutral tones.

1. The artist begins by painting the sky with a very diluted wash made up of cerulean blue and burnt sienna. By adding emerald green to this same mix, the artist gets the color for the sea.

1

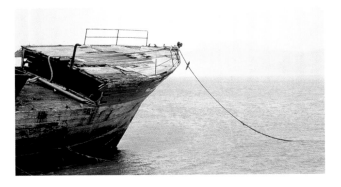

2

4

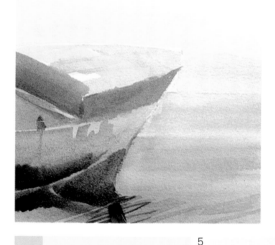

2. The artist adds a hint of ultramarine blue to the color used for the sea to paint the mountains in the background. Then, having washed the brush, the artist paints the deck of the ship with pure cerulean blue and, directly next to it, a few strokes of diluted burnt sienna.

3. A mix of burnt sienna and black provides the artist with a sepia color to paint the other part of the deck.

4. The artist has applied a very diluted sepia glaze to the ship's hull to tint the colors that will now be painted on top: a strip of pure burnt sienna in the upper section; a diluted version of this sienna in the middle section; and, in the lowermost part of the hull, sepia, but this time with a touch of ultramarine blue.

3

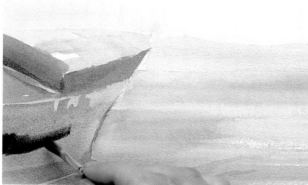

This is what the palette looks like after finishing this exercise. Notice that the only recognizable color of the range that has been used is the burnt sienna, which formed part of each one of the mixes. If you followed this exercise step by step, you may have noticed that up to four colors were used in certain mixes.

■ When you paint with neutral colors, you should take advantage of the leftover paint on the palette to give gray tones to other colors. They can also be altered by using dirty water. The artist also should not worry about cleaning the brush thoroughly.

5

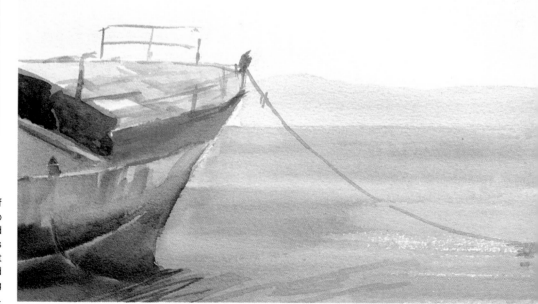

5. The artist has added a touch of emerald green to the last mix to make a dark green that is brushed over the water to suggest shadows and reflections. To finish, the artist paints the details of the line and the rail using the paint remaining on the palette.

White

Because there is no white watercolor paint, the artist has to use the white of the paper. This means that you will have to "reserve" the white areas before, or while, you are painting. You may ask how someone could paint a picture using white as the predominant color of the subject. How would its forms and volumes be conveyed without using white paint? The answers to these questions are provided in this chapter.

The artist will use only three of the seven given colors to paint this picture: ultramarine blue, burnt sienna, and black.

These are the colors that have been used in this exercise. Notice how, in most cases, the artist has applied these glazes diluted with plenty of water: (a) ultramarine blue; (b) burnt sienna with a touch of ultramarine blue; (c) the same as (b) except less diluted; (d) burnt sienna with a tiny spot of ultramarine blue; (e) the previous mix only with inverse proportions, a slightly gray ultramarine blue, very, very diluted; (f) here, a hint more ultramarine blue has been added to the previous mix; the vertical glaze is the same as (d), only very diluted.

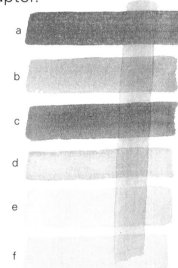

a

b

c

d

e

f

Whitewashed Walls

For this exercise, a typical Andalusian house that has various shades of white and shadows has been chosen.

1. The artist's first task is blocking in the shrubs and trees on the right to establish shapes and tonal values. Then, with a very diluted wash of ultramarine blue tinted with black, the artist begins to paint the uppermost areas of the wall.

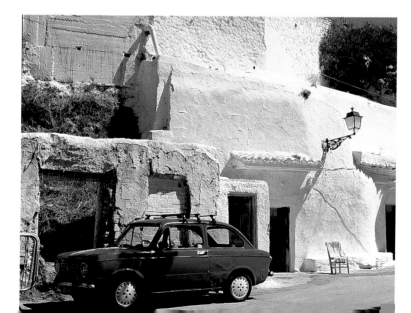

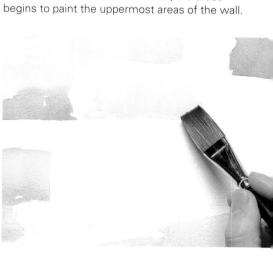

2

2. Using burnt sienna mixed with some of the previous color, the artist paints the areas where the white is not as cool or as dark. It is important to paint the shadows and give some color to other parts, so that you can develop the necessary contrast.

3

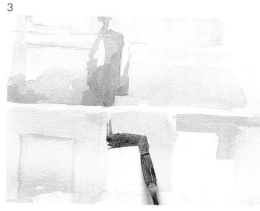

3. The artist has continued to establish volumes by slightly varying the hues and intensity of the tones. The artist uses ultramarine blue to begin to suggest the shadow of the door frame, then adds black to get a pale, steely gray.

4

4. The left part has been retouched to give shape to the shrubs, and suggest the texture of the peeling wall.

5

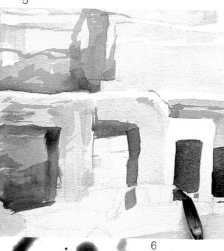

5. The dark areas of the lower part have been filled in. The artist uses the more intense tones of burnt sienna mixed with black or ultramarine blue to paint the hollows of the door.

REMEMBER . . .

■ If you followed this exercise step by step, you may have noticed that most of the textures and volumes of the wall were suggested using only very diluted grays. Despite this, the artist managed to produce the desired effect. Because the white of the paper has neither volume nor texture of its own, it was necessary to use color, which also creates contrasts by making the light areas seem even brighter.

6. The last steps are to paint the car to emphasize the contrast, and add the final details.

6

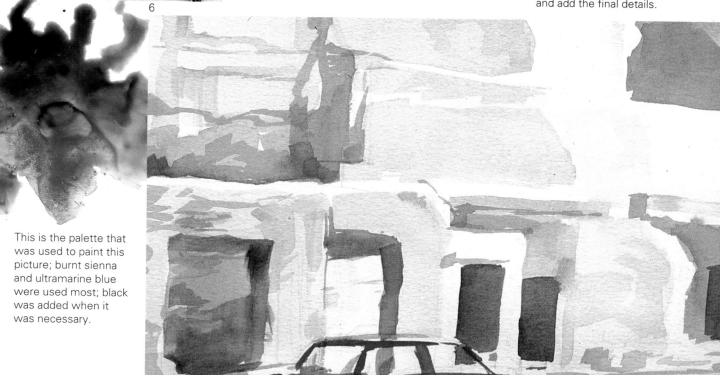

This is the palette that was used to paint this picture; burnt sienna and ultramarine blue were used most; black was added when it was necessary.

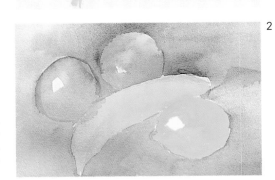

Yellow

Yellow is the ultimate warm color, and it is used to make the brightest colors. Yellow is a color that naturally suggests the idea of light, because sunlight always has some yellow in it. Yellow is also one of the most intense colors, especially lemon yellow, which has some particularly "acid" tones.

These glazes are some of the colors that have been mixed to paint this subject: (a) a very diluted orange, the result of mixing yellow and crimson with a greater quantity of yellow; (b) yellow mixed with leftover paint from the palette; (c) a very diluted tone made from a combination of emerald green and yellow; (d) almost sepia brown resulting from a mix of emerald green and burnt sienna; (e) another very diluted green, but instead of yellow, burnt sienna has been added to the emerald green. The vertical stripe is pure yellow.

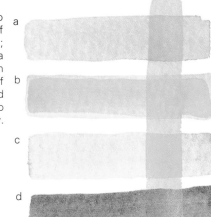

To paint this exercise in yellow, the artist uses four of the seven colors of the palette: medium yellow, crimson, burnt sienna, and emerald green.

Yellow Fruit

The artist has chosen this still life of fruit because it contains a variety of yellow colors and tones.

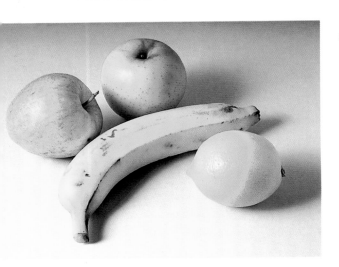

1. The artist starts by determining the colors of each piece of fruit: the lemon is pure medium yellow; the banana has a touch of crimson; the apple behind it is a combination of emerald green and yellow; and the other apple is a mix of yellow and burnt sienna, touched with crimson at certain points.

2. When the green apple is finished, the background is painted with this grayish color, a mix of emerald green and burnt sienna, to contrast with the yellow, as yellow on white loses some of its brightness. The artist pauses to consider the shadows: Notice that the different colors of each of the fruits have been exaggerated to emphasize the yellow lemon.

3

3. The artist begins to paint the fruits' shadows with the same color used for the background, emerald green mixed with burnt sienna, though less diluted.

4

4. You can use variations of the background color to paint the volumes of the different fruit. A little more emerald green is added to the apple; more burnt sienna can be added to the most ocher-colored parts of the banana and the lemon, and more green can be added to the green areas.

5

5. Notice the differences in the fruit from the previous stage. When the last brushstrokes have had time to dry, the artist applies a medium yellow glaze over each piece of fruit to unify the colors of the work.

■ Yellow is a sharp, or "acid" color by nature. For this reason, and because it is brightest, it can create problems in mixes. It is recommended that you mix yellow with primary, or pure secondary colors, because it tends to produce grays when mixed with a number of dark tones or neutral colors.

REMEMBER . . .

This is how the palette looks at the end. You can clearly see the different mixes.

43

Mixing Watercolors **Creating Tones**

6

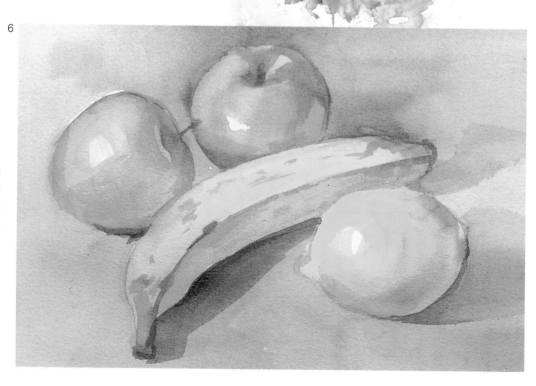

6. At the end of the exercise, you can see that the work has a certain unity, even though each piece of fruit has its own specific hues: the lemon has a brighter yellow than the others and is more "acid," the banana is yellow with shades of ocher, and the apple behind the banana has greenish hues.

Reds and Oranges

Red is also in the range of warm colors, along with orange, which is composed of yellow, red, and sometimes touches of cool colors like violet.

These are some of the colors used to paint this picture. Most of them are the result of mixing colors: (a) burnt sienna with a small amount of crimson; (b) the same mix as (a), but with slightly more crimson, and applied in a diluted form; (c) the previous color, less diluted, with a touch more crimson; (d) an orange tone composed of a yellow muddied with a touch of emerald green and a hint of burnt sienna; (e) a diluted mix of yellow and emerald green; the strip of color running through the others is the hue used to paint the background, a combination of burnt sienna and a little emerald green.

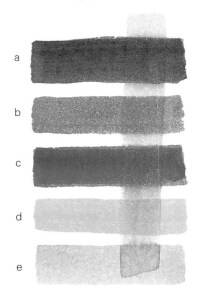

To paint this exercise containing different shades of red and orange, the artist has used four of the seven colors of the palette. They are the same ones that were used in the chapter devoted to yellow, only this time they will be used to produce different results: medium yellow, emerald green, crimson, and burnt sienna.

Red and Orange Vegetables

In this exercise, the artist will paint a small still life made of fruit and vegetables, each of which has its own distinct shade of red or orange.

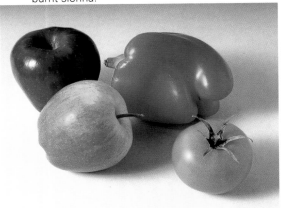

1. The artist begins by painting the background with a very diluted wash of burnt sienna with a touch of emerald green; the same components used for the last background color, but in inverse proportions. A more intense version of this color is used to suggest the shadows of the objects. The artist then renders the brightest parts of the apple with pure crimson, adding burnt sienna to it for the darker areas.

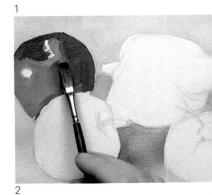

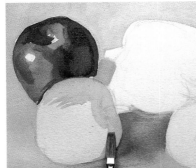

2. The other apple is painted with a yellow wash barely touched with the slightest hint of burnt sienna, and an even tinier amount of emerald green.

3

3. Once the first application has dried, the artist adds a second layer of crimson. See how it acquires shades of orange in the parts that were painted in yellow before.

4

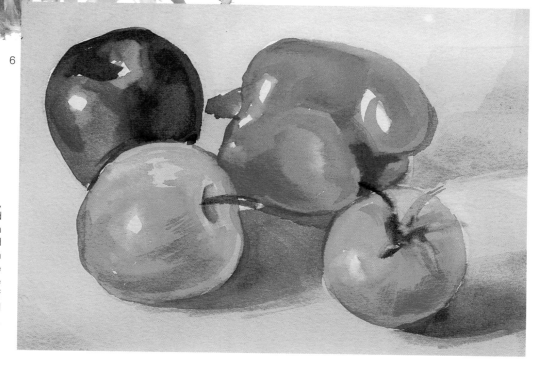

4. The artist tries to suggest the mottled quality of the apple while painting it, by using a less diluted crimson. It is also used to heighten the shadow it casts, both to integrate it within the whole, and to make it really reflect its color. Then, the artist paints the red pepper using vermilion, a combination of yellow and plenty of red, and brings out the vegetable's shine by absorbing color with the brush.

5

5. The shadows—both those cast by the pepper, and those on it—have been painted with diluted crimson. The tomato is painted with a mix of crimson and yellow with a touch of burnt sienna, leaving the parts in the shadow in crimson, and the highlights in yellow.

REMEMBER . . .

■ Most shades of red and orange are extremely warm. They are used to paint subjects from human flesh to plowed land. Reds, in particular, are present in the mixes of almost all ochers, browns, and maroons. The primary color pure red, or the paint crimson, is especially important because it is used to make many of the other colors in this range.

45

Here are the mixes used to paint this picture.

6

6. As a finishing touch, the artist has reinforced the tomato's shadow with a glaze of the background color, whereas its stem has been painted with the same green used in the pepper and apple, a mix of emerald green and vermilion.

Green

Because green contains the warm color yellow and the cool color blue, it can seem either warm or cool. Green is situated between red and blue, and is a color that is found in vegetables, and, above all, in landscapes.

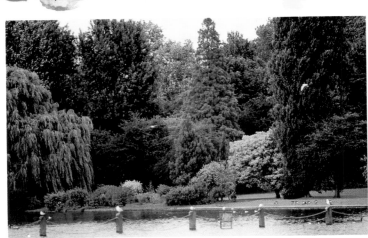

To paint the range of greens in this exercise, the artist has used five of the seven colors of the palette: medium yellow, emerald green, ultramarine blue, burnt sienna, and ivory black.

A Group of Trees

The subject chosen for this exercise in green is the corner of a park where a group of trees offers an interesting range of green tones.

The artist has used warm and cool colors to paint this picture: (a) a pure medium yellow; (b) a warm green containing a touch of burnt sienna, emerald green, and plenty of yellow; (c) ultramarine blue with a touch of emerald green; (d) burnt sienna touched with emerald green; (e) semidiluted emerald green with a touch of black; (f) emerald green, with a greater proportion of black, and applied with less water; the horizontal stripe is (b), but more diluted.

1. The artist begins by painting the brightest trees with yellow mixed with a hint of emerald green. Next, the artist paints the cypress with an opposing mix, that is, emerald green mixed with the slightest bit of yellow.

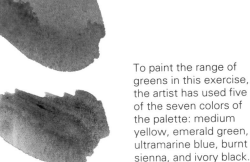

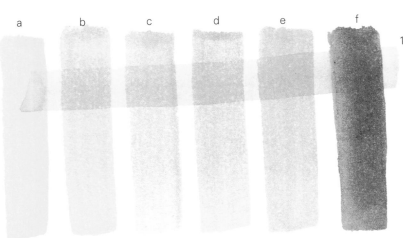

a b c d e f

1

2

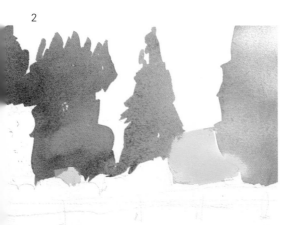

2. The trees on the left have been painted with emerald green slightly darkened with burnt sienna. The artist then adds a touch of yellow to this mix in order to paint the "acid" green of the fir tree in the center.

3. The trees in the background are painted with ultramarine blue tinged with emerald green. The green used for the fir tree in the center is still intact on the palette, so the artist takes advantage of it, adding a hint more yellow, to paint the shape of the weeping willow on the left. The artist also uses it as a glaze to lighten the tree on the left.

3

4

4. While the glaze is still wet, the artist applies several soft dabs of burnt sienna to suggest the shadows. Now, the artist mixes a little yellow with a greater amount of emerald green, and paints several strokes over the trees on the left. The darkest shadows are made from a mix of black and emerald green.

In a case like this, in which a green is surrounded by other greens, it is inevitable that some of the hues will overlap others. The best way to capture this subtle effect is by taking advantage of the leftover colors on the palette to emphasize the "breaks" in colors. It is also important to avoid cleaning your brush too much: this way the work will have a more monochromatic tone.

■ The quality of a green is determined by its composition. If the proportion of blue in the mix is greatest, the color will take on a cool quality and seem more refreshing to the eye. If, on the other hand, yellow predominates, the green tone will seem warmer and more strident.

5

5. You will notice in the finished exercise that the water and grass have been painted, and that several shadows have been added in the trees. All these colors have been made from leftover paint on the palette. Thus, the color of the water is a very watered-down emerald green muddied with some umber, and probably with ultramarine blue. The brown tones are the result of burnt sienna, and a greater or lesser amount of emerald green.

Earth Colors

Just as their name suggests, earth colors are used to represent the mineral parts of nature: sand, rocks, plowed land, and mud. Just like green, these colors can take on a variety of qualities, although they are generally warm because of the large amount of yellow and crimson in their composition.

To create the earth colors for this subject, the artist has used five of the seven colors of the palette: cerulean blue, emerald green, burnt sienna, medium yellow, and crimson.

These are the mixes that have been used in this exercise: (a) crimson tinted with a little burnt sienna; (b) crimson and burnt sienna, but with a larger proportion of sienna; (c) burnt sienna mixed with yellow, the slightest hint of crimson, applied very diluted; (d) a large proportion of burnt sienna, and just a touch of green; (e) a mix the opposite of (d), emerald green with a bit of burnt sienna; (f) a cerulean blue neutralized with the slightest bit of burnt sienna; the vertical strip is a mix of burnt sienna with very diluted crimson.

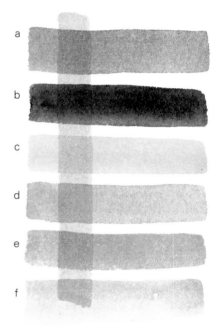

a

b

c

d

e

f

Volcanic Earth

This volcano has been chosen as a subject because it has an interesting range of earth colors.

1. The artist begins by painting the sky with a soft glaze of cerulean blue, lightly tinted with yellow. Afterward, the artist fills in the earth tones using ocher, a combination of burnt sienna and yellow. While applying this glaze, the artist loads a touch of green on the brush, and applies it over the still wet paint, so that both colors blend naturally.

1

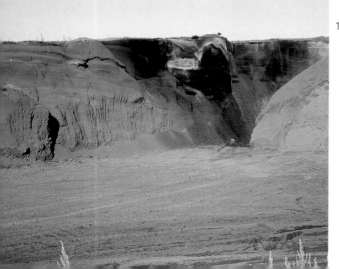

2

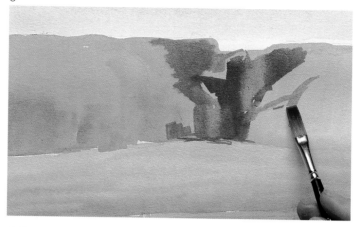

3

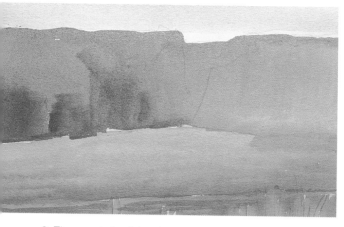

2. The area in back has been painted with the earlier mix of burnt sienna, altered slightly with a touch of yellow. Like before, while the paint is still wet, the artist adds strokes of crimson. This way, it blends with the background color.

3. The artist paints the crater with a mix of burnt sienna and crimson, applying more of one or the other colors according to the nature of the area. The artist then applies burnt sienna with a touch of emerald green to the darker areas. After that, the artist paints the jagged surface of the slope with the burnt sienna and some yellow.

Here are the mixes used to paint this exercise.

REMEMBER . . .

■ If you followed this exercise step by step, you may have noticed that burnt sienna was included in all the mixes. This color is easy to produce using the three primary colors. Its approximate proportions are one-quarter cerulean blue, one-quarter yellow, and two-quarters red. The result of this is clearly a warm color.

4

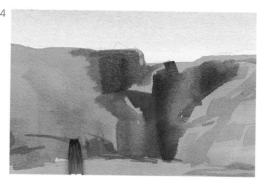

4. Once again, the artist uses the mix of burnt sienna and crimson to apply several small glazes to the left-hand wall. These suggest both the prevailing tone there, and the fissures in the earth.

5

5. With the exercise completed, you can appreciate the way the unevenness of the slopes and the ground has been suggested through superimposed glazes of the base colors. The final touches consist of painting the shrubs in the foreground with a yellow muddied with the leftover colors on the palette. These mixes bring out the warm quality of the work. The only truly cool color here is the cerulean blue used to paint the sky.

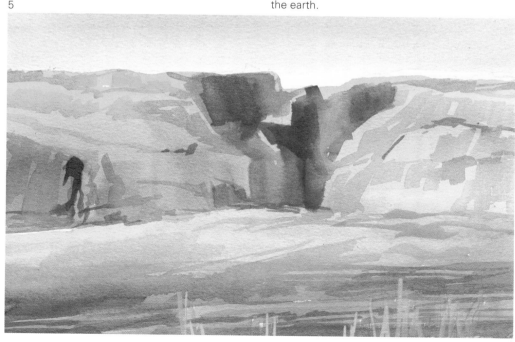

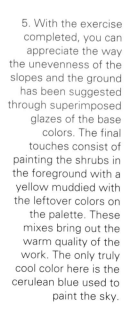

Blue

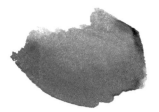

Blue is a cool color readily found in nature. Water and sky tend to be blue, and very often have more than one shade of this color. Sometimes they may take on an entire range of different tones.

Here is the range of colors that have been used to paint this exercise: (a) cerulean blue, very diluted, with a dash of emerald green; (b) violet blue, applied semidiluted, made of cerulean blue and crimson; (c) a very diluted glaze of ultramarine blue; (d) semidiluted pure emerald green; the horizontal band is semidiluted cerulean blue.

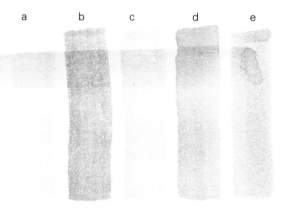

To practice painting with a range of blue tones, the artist uses four of the seven colors of the palette: cerulean blue, cobalt blue, emerald green, and crimson.

The Caribbean

This fragment of Caribbean coastline has been chosen to practice painting with an attractive range of blues.

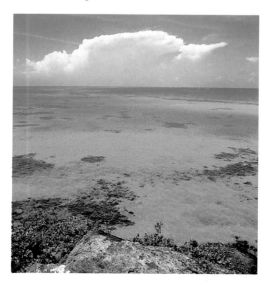

1. The artist begins by painting the uppermost part of the sky with a glaze of ultramarine blue, afterward adding cerulean blue above the horizon line. See how the shape of the cloud has been reserved by leaving an area unpainted.

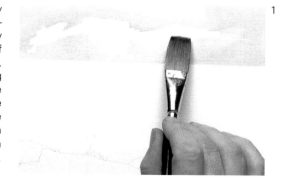

2. The artist makes the color for the water by mixing cerulean blue and emerald green. This is applied with large brushstrokes, leaving the brightest areas temporarily unpainted.

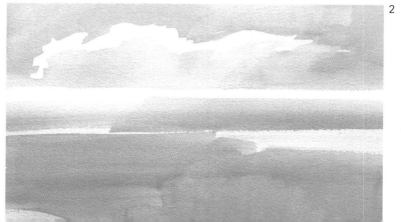

3

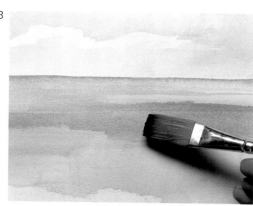

3. Once this base color has dried, the artist applies a glaze of pure cerulean blue to get the turquoise color of the water.

4. The waves on the surface of the water are suggested with tiny strokes of the emerald green mix used for the background. The artist then mixes ultramarine blue with a little crimson to get an intense blue to paint the seaweed that can be seen resting on the bottom.

4

5

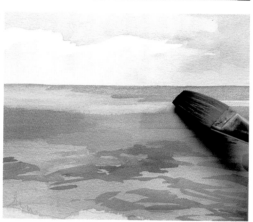

5. The artist has softened the outlines of the seaweed and added several more touches to the surface of the water. Having examined the overall tones, the artist decides to slightly darken the color of the background. Another glaze of cerulean blue has been applied over the background to highlight the turquoise blue.

The palette is an excellent guide for studying and discovering the mixes carried out during the painting process.

51

REMEMBER . . .

■ When the subject itself is not blue, blue tones can be used to complement warm colors, create grays, and, above all, produce shadows.

6

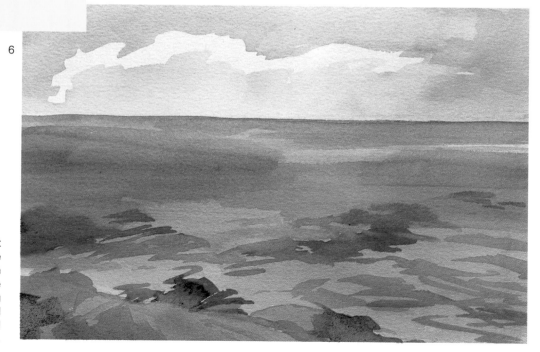

6. Finally, the artist paints the part of the land that creates a contrast with the blue tones, heightening their intensity, and bringing out the real color.

Gray

Gray is produced by mixing the three primary colors together in different proportions; for this reason gray is an undefined and neutral color. Gray can be found in any subject, interior or exterior, because it is often present in shadows. It may also seem warm or cool depending on the proportions of its components.

To produce the shades of gray needed for this exercise, the artist uses five of the seven colors of the palette: medium yellow, emerald green, ultramarine blue, burnt sienna, and ivory black.

Pay special attention to this range of grays. At first glance they may seem to be tones of black, but in fact they are entirely different shades: (a) ivory black applied with little water; (b) this dark brown is a semidiluted combination of half ultramarine blue and half burnt sienna; (c) although it does not look like it, this is the same color as (b), but more diluted. It is, in other words, a lighter tone; (d) more burnt sienna has been added to the previous mix to make it warmer, and it has also been diluted; the vertical strip is the same gray as (c), but even more diluted.

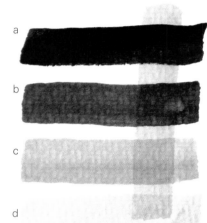

Seasoned Wood

This exercise allows the artist to paint a series of gray tones using an old wooden fence as the subject.

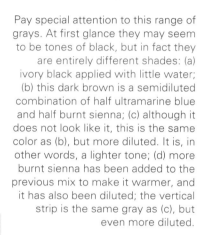

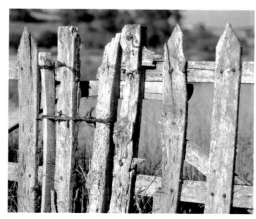

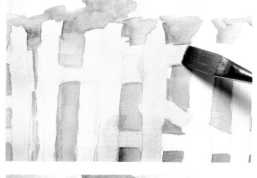

1. The artist begins by painting the background behind the fence in such a way that it highlights the brilliance of the gray. In progressing, the artist tries to determine the correct intensity of the tones. Then, using a warm gray color consisting of cerulean blue and a greater amount of burnt sienna, the artist applies a general glaze over the entire area of the fence.

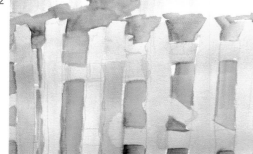

2. The fence has been covered with the background glaze. Notice how, from the very beginning, some parts have been made lighter than others. The artist clarifies and intensifies the tones while painting.

3

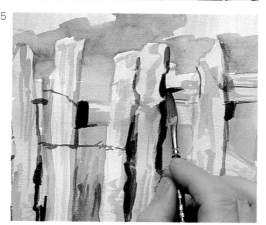

3. The artist now begins to suggest volume by adding shadows made of equal parts of emerald green and burnt sienna. Notice how, in the case of these shadows, the tone is applied diluted to different degrees depending on the nature of the area.

4. The intense color of the shadows is reduced to an intermediate one by adding some ultramarine blue to the mix. By diluting the paint still further, the rough texture of the wood can be suggested. The colors used for the grass and lower area are chosen to give more contrast.

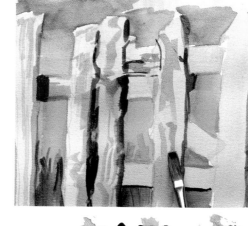

4

5

5. The artist pauses to consider the state of the painting, and decides to add the details, and touches up and intensifies parts of the shadows with black. When black covers the background color, it takes on brown hues.

The palette still shows the colors that were mixed as well as the original colors used to produce them.

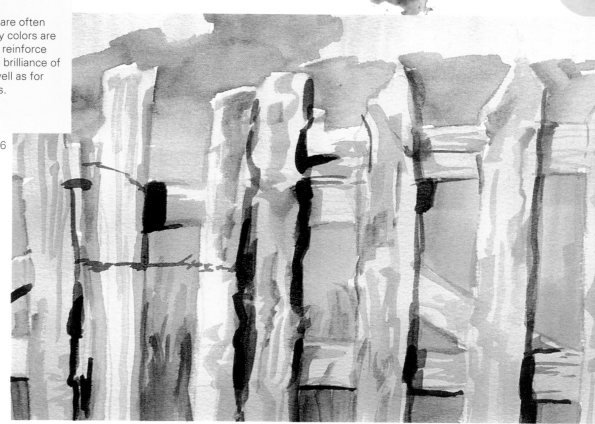

REMEMBER . . .

■ Neutral colors are often called grays. Gray colors are used primarily to reinforce and heighten the brilliance of pure colors, as well as for painting shadows.

6

6. In the completed exercise, you can appreciate the different colors and tones used, and how the background was used to create a contrast with the grays. If you followed the mixes step by step, you may have noticed that the artist never applied watered-down black to suggest gray. It is best to be more concerned with discovering richer and more interesting shades than with convenience.

Flesh Colors

The colors of human flesh are a mystery for the novice painter. There is no single color that can be used to paint skin, because each person, and each part of the body, is made up of different colors. As a result, when artists paint flesh colors, they are compelled more than ever to rely on color mixes.

To make the skin colors of this model, the artist uses five of the seven colors of the palette: ultramarine blue, medium yellow, emerald green, crimson, and burnt sienna.

These are some of the hues that have been used to paint this exercise: (a) brown, a product of a combination of a large amount of crimson and emerald green; (b) a glaze of pure burnt sienna; (c) applied as a wash, crimson with a touch of emerald green; (d) it is surprising how a color can change depending on its tones. This is burnt sienna, color (b), but very diluted; (e) ocher produced from a combination of a large amount of yellow, a little crimson, and a touch of burnt sienna; the horizontal strip is a diluted mix of emerald green with burnt sienna.

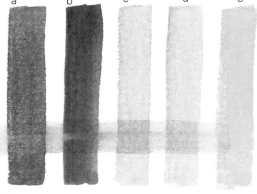

1

Skin Tones

To learn about the colors and textures of human flesh, a section of this nude will be painted.

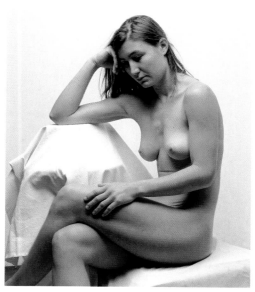

1. The artist begins by applying a base glaze of very diluted burnt sienna. The shoulder on the left has been tinted slightly with a little crimson.

2

2. To intensify the tones in the darkest areas, the artist applies another layer of the burnt sienna glaze, though in a more diluted form. The new layer of glaze will intensify the color. The area below the right breast is darkened with burnt sienna tinted with a little emerald green.

3. The shadow of the arm has been painted with semidiluted burnt sienna. The shadow of the neck is painted with a mix of emerald green and crimson, in equal parts, with a tiny bit of ultramarine blue. The collarbone has been rendered with an orange color made of burnt sienna and yellow.

3

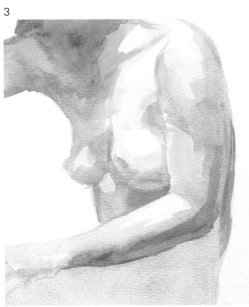

4

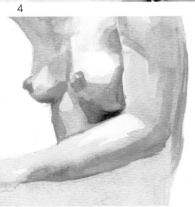

5

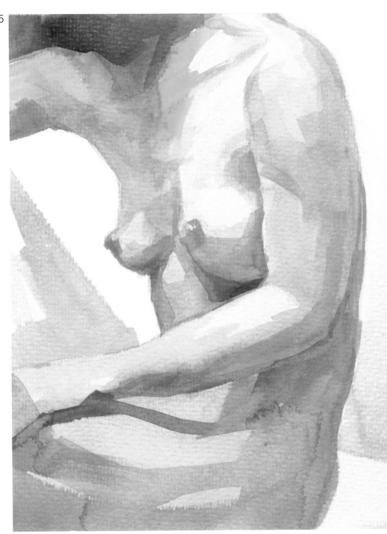

4. Having blocked in the colors of the upper half of the model's trunk, the artist begins adding details. With a mix composed of crimson with a little burnt sienna, the artist paints the nipples and bolsters the shadows under the breasts.

The palette reveals both the mixes and the original colors used to make them.

5. To finish, the artist uses the previous mix of emerald green and crimson, although without the blue, to intensify the shadows at the top parts of the neck. To suggest the background, the artist has added several brushstrokes of a gray made up of burnt sienna with very diluted ultramarine blue.

Bright Colors

Bright colors owe their brilliance, shine, and intensity to the purity of their components, that is, unmixed pure colors. These hues contain only two primary colors.

To paint this exercise the artist has used four of the seven colors of the palette: medium yellow, crimson, emerald green, and ivory black.

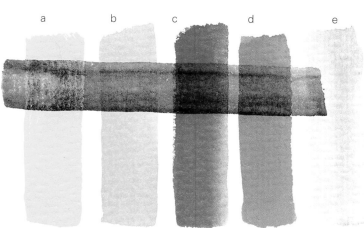

This is a sample of the mixes used to paint this exercise; the ones shown here contain, at the most, only two primary colors; (a) pure medium yellow; (b) orange made by adding a dash of crimson to the yellow; (c) pure, unmixed crimson; (d) vermilion, a little crimson combined with yellow; (e) a very diluted crimson; the horizontal color strip is pure emerald green.

Flowers in Their Natural Environment

For this exercise devoted to bright colors, this exquisite image of flowers in the countryside has been chosen, where the colors are filled with light.

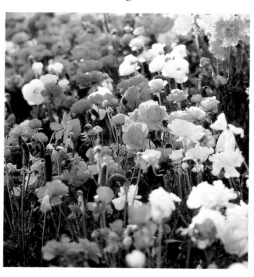

1

1. To paint the pinkish flowers, the artist uses pure crimson though diluted to a greater or lesser degree. Vermilion—a mix of crimson and yellow—is used to paint the flowers in the foreground.

2

3

2. To suggest the white flowers, the artist has added a dash of yellow to the emerald green, and applied it in an extremely diluted form. The artist paints the yellow flowers with brief dabs of pure yellow: yellow over crimson produces orange, which will be used to make orange flowers.

3. The grass is rendered with emerald green mixed with a little black; the black darkens the green, which, when juxtaposed with pure colors, makes them seem even brighter.

4

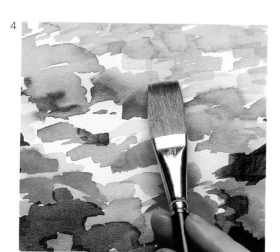

4. The artist applies several strokes of pure yellow to the areas that seem too weak or insufficient.

You can clearly see on the palette the colors used in this exercise, and how few mixes were made.

5

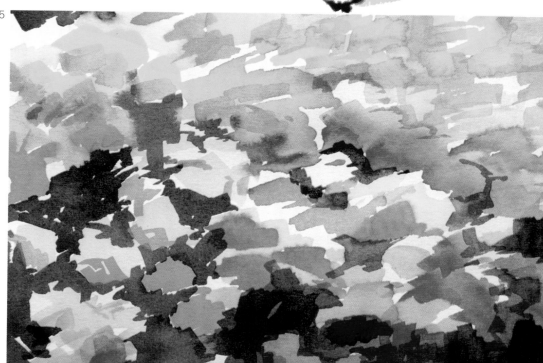

5. Notice in the completed work how the picture has been given several strokes of a diluted orange wash in the right-hand corner, and that the grass has been slightly touched up.

Dark Colors

Dark colors pose a real challenge. Watercolor is a difficult medium in which to lighten colors, because it is not possible to superimpose a light color over a dark one. It is also more difficult to darken a dark tone than a light one, so the execution of a work with dark colors is far more complex.

In this exercise, the artist uses all seven colors of the palette for the first time: medium yellow, crimson, burnt sienna, cerulean blue, ultramarine blue, emerald green, and ivory black.

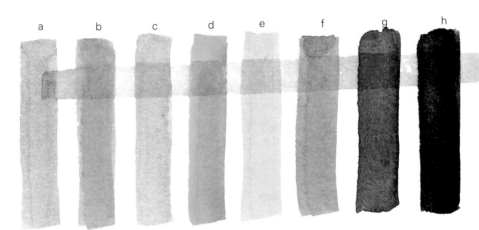

a b c d e f g h

These are some samples of the colors used to paint this picture: (a) a very thin wash of emerald green; (b) emerald green with a large proportion of yellow, and only a little crimson; (c) a rather diluted color, the result of a mix of crimson with a touch of burnt sienna and another of ultramarine blue; (d) orange, which is a mix of crimson and yellow, (e) ocher tone, made by combining the three primary colors: yellow, crimson red, and cerulean blue, with the greater proportion being of yellow; (f) a glaze, made of burnt sienna with a touch of ultramarine blue; (g) brown, which is burnt sienna with a hint of black; (h) black without any mixes; the horizontal color strip is emerald green tinted with a small drop of burnt sienna in a dilute wash.

1

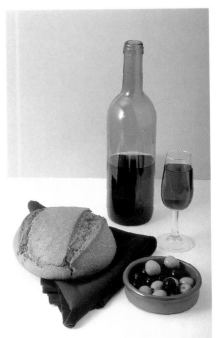

Bread and Wine

This still life of a bottle of red wine and a loaf of brown bread on a napkin is an ideal subject for working with dark colors.

1. The artist begins painting with the darkest color, blocking in the napkin with a combination of burnt sienna, emerald green, and a touch of black. This same color is used to suggest the napkin's reflection on the bottle. The bread is rendered with a watered-down mix of burnt sienna and a little yellow. Then, the artist makes a reddish brown color with a mix of burnt sienna and yellow to paint the ceramic dish.

2. The artist renders the green olives first with a mix of emerald green, yellow, and the tiniest bit of crimson. The black ones are painted next, using unmixed ivory black.

2

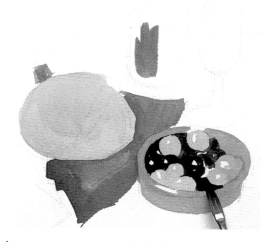

3

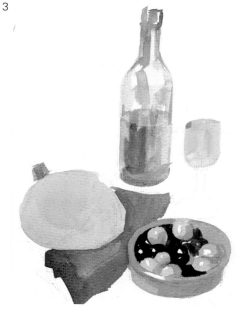

3. The wine in the bottle has been painted with a very diluted crimson mixed with a touch of ultramarine blue; the glass has been painted with vermilion, also very diluted, which is a mix of crimson and yellow. Some of this color should be kept for the highlights. The glass of the bottle is mostly pure emerald green, though yellow is used in the lightest parts.

4

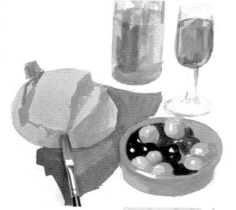

4. The orange color representing the wine in the glass is made of a portion of yellow, and a greater amount of crimson. The reflections have been suggested with the same tone used to paint the napkin. The glass is painted with a very thin gray wash made by tinting the emerald green with a bit of burnt sienna. An application of pure burnt sienna is used to paint the shadows on the bread.

5. To finish the work, the shadows and folds of the napkin are painted with glazes of semidiluted black, and the background with emerald green mixed with burnt sienna; this gray emphasizes the highlights and increases their brightness.

5

The palette displays some of the mixes used in this exercise.

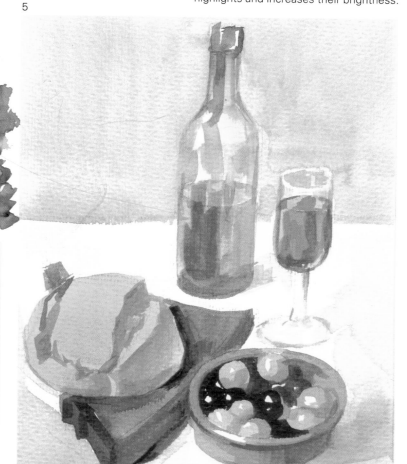

REMEMBER . . .

■ Glazes are used to darken colors in watercolor. After they dry, they lose some of their intensity. It is easy to darken a color while it is still wet, but making dried colors darker is more complicated. You should practice a lot with dark colors to get experience with them.

Pale Colors

In watercolor, pale colors are simply those applied very diluted. Therefore, any color can be turned into a pale color: it is only a matter of adding more water to the paint. A pale color is nothing more than one of the light tones of a color.

To paint this exercise, the artist has used all seven colors of the palette: medium yellow, crimson, burnt sienna, cerulean blue, ultramarine blue, emerald green, and ivory black.

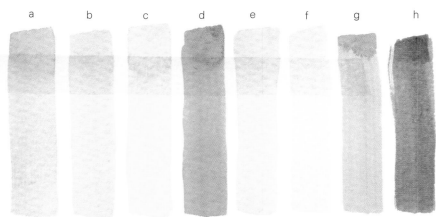

a b c d e f g h

Here are the pale colors used in this exercise. It may come as a surprise to learn that some of the colors contain no mixes: (a) a very diluted emerald green; (b) a very diluted, unmixed burnt sienna tone; (c) a combination of burnt sienna with a little yellow; (d) a mix of semidiluted burnt sienna with a bit of emerald green; (f) a very diluted crimson; (g) crimson with a little burnt sienna applied semidiluted, a mix that is proportionally opposite to (d); (h) semidiluted emerald green; the horizontal strip is very diluted emerald green.

A Teddy Bear

This teddy bear on a beige sofa has been chosen to demonstrate the use of pale colors.

1. The artist paints the entire surface of the sofa with a wash containing burnt sienna with some emerald green. The proportion of emerald green is increased for the seat cushions. The pillow on the right has been painted with the same color, except that a touch of yellow has been added in the top part, and cerulean blue in the bottom. The wall in the background has been covered with very diluted cerulean blue.

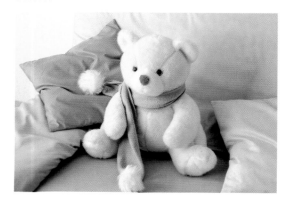

1

2

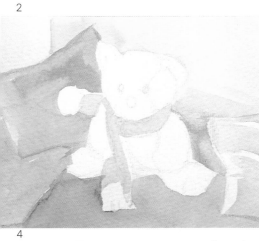

2. The artist has painted the scarf pink, which is only very diluted crimson, and the pillow with emerald green, also diluted.

3. To suggest the volumes of the teddy bear, the artist mixes a gray of cerulean blue combined with burnt sienna, and applies it very diluted over the paper.

3

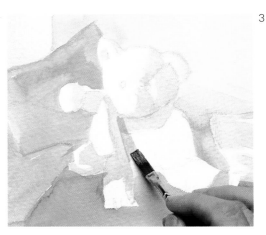

4

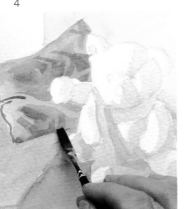

4. Once the different areas of color have been blocked in, the artist begins to suggest volume by means of shadows. The first glazes have been left to dry so you can see the real intensity of their color. The pillow is painted with the same diluted emerald green as before; by applying a second layer, the artist is able to intensify the color.

5

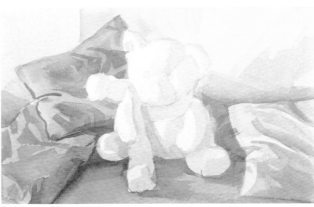

61

5. All the shadows of the sofa and the folds of the cushions have been painted with the background colors as diluted as those applied earlier. The same goes for the other colors. By applying a glaze of the same color, you intensify the color; you don't change it.

REMEMBER . . .

■ Pale colors do not really exist in watercolor. They are only tones of darker colors. When you paint with pale colors, you should remember that superimposing, or layering, glazes always intensifies the color.

6

The palette shows the colors used and some of the mixes made in this exercise.

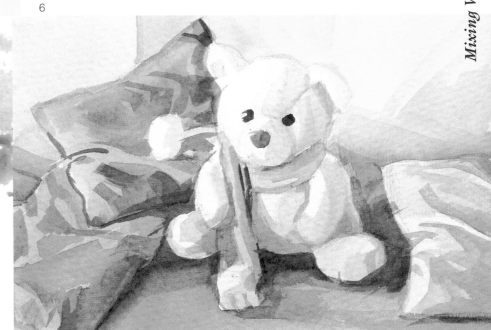

6. To finish up, the folds of the scarf have been painted with burnt sienna tinted with a little ultramarine blue. The bear's nose is a mix of cerulean blue and emerald green; the left eye has been painted black, and the right eye is a dab of ultramarine blue.

Intense Colors

The intensity of a color is determined by its composition, and the amount of water used to apply it; it also depends on the contrast produced by the colors that surround it. Each color has a different degree of intensity that is at its maximum when contrasted with its complementary color.

In this exercise, the artist uses all seven colors of the palette: medium yellow, crimson, cerulean blue, ultramarine blue, emerald green, burnt sienna, and ivory black.

The colors used in this painting are the result of mixes that produce clean, sharp colors: (a) an unmixed, semidiluted glaze of black; (b) a vermilion made from a mix of crimson and yellow, with slightly more of the latter; (c) a combination of ultramarine blue and cerulean blue; (d) green produced by mixing emerald green and yellow; (e) pure medium yellow applied with very little water, so it maintains its intensity; the horizontal strip is a very diluted version of the earlier green.

Parcheesi

For the present exercise, the game pieces, die, and dice holder of a Parcheesi set have been chosen, because their four colors are obviously intense, and also function as complementary colors (red-green, yellow-blue).

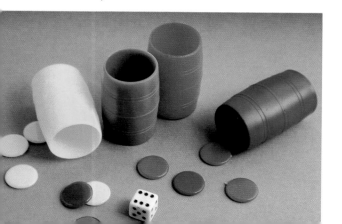

1

1. The artist begins by painting the game pieces and the yellow dice holder with a medium tone that is intensified on one side of the shadow. Crimson and yellow produce the vermilion that the artist uses to paint the red dice holder.

2

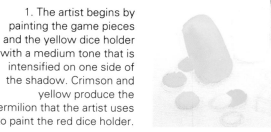

2. For the blue dice holder, the artist uses a mix of the two blues of the palette—cerulean blue and ultramarine blue—reserving the white of the paper to represent the shiny side. The shadow of the inner part is composed of ultramarine blue and vermilion.

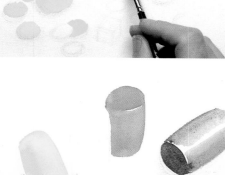

3

3. The artist paints the green dice holder with a mix of emerald green and yellow. The interior shadow is painted in a brown made from green with a touch of vermilion. This color was diluted a little to paint the faces of the die.

4

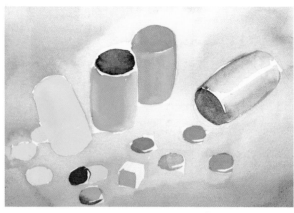

5

5. The artist has painted the interior shadow of the yellow dice holder with a very diluted burnt sienna. The red one's shadow is vermilion tinted with black. With the same colors used to paint the external parts of the dice holders, the artist begins painting their shadows.

4. The artist paints the background with a neutral color that contrasts with the pure colors of the Parcheesi set, in this case, emerald green tinted with black. Notice how in the right-hand corner the gray has been tinted with a touch of ultramarine blue to heighten the cool quality of this side. On the left-hand side, the proportion of emerald green has been increased to make it warmer.

The mixes on the palette show how the intense colors were varied to suggest the shadows.

6

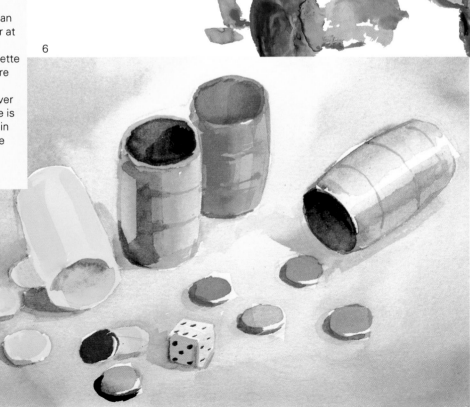

6. The exercise is completed, so you can see the details that were added during the final phase. The dots were added to the die and the shadows cast by the dice holders have been elaborated. Notice how the shadow of the blue dice holder contains a little green, just as the red one does, whereas that of the red dice holder is cool. The yellow one contains green. This is a good demonstration of contrasts.